DON'T DIE

POEMS 2013-2021

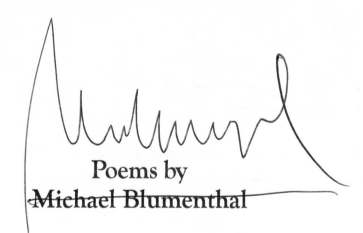

Poems by
Michael Blumenthal

RABBIT HOUSE PRESS

Versailles, KY 40383

www.Rabbithousepress.com

ISBN: 978-1-7351727-9-8

Cover Art- Sculpture of Michael Blumenthal by Jonathan Hirschfeld
Cover and Interior Design: Corbyn Keys

For inquiries about author appearances and/or volume orders contact:
Rabbithousepress@gmail.com

ALSO BY MICHAEL BLUMENTHAL

POETRY

Sympathetic Magic (The Water Mark Press Poets of North America
First Book Prize, 1980)
Days We Would Rather Know (Viking-Penguin, 1984)
Laps (University of Massachusetts Press Juniper Prize, 1984)
Against Romance (Viking-Penguin, 1987)
The Wages of Goodness (University of Missouri Press, 1992)
Dusty Angel (BOA Editions, Isabella Stewart Gardner Prize, 1999)
AND (BOA Editions, 2009)
No Hurry: Poems, 2000-2012 (Etruscan Press, 2013)

FICTION

Weinstock Among the Dying: A Novel (Zoland Books, 1992, Harold
U. Ribelow Jewish Book Prize)
The Greatest Jewish-American Lover in Hungarian History: Short
Stories (Etruscan Press, 2014)

NON-FICTION

When History Enters the House: Essays from Central Europe
(Pleasure Boat Studios, 1998)
All My Mothers and Fathers: A Memoir (Harper Collins, 2002)
Just Three Minutes Please: Thinking Out Loud on Public Radio
(Vandalia Press, 2014)
"Because They Needed Me:" The Incredible Struggle of Rita Miljo
to Save the Baboons of South Africa (Pleasure Boat Studios,
NY, 2016)

TRANSLATIONS

And Yet: Selected Poems of Péter Kántor (Irodalom Publishers, Budapest,
 2000) (from Hungarian)
Unknown Places: Poems by Péter Kántor (Pleasure Boat Studios, NY,
 2010)
Fahjem: Clear Blue Sky, by Constantin Himmelried (CreateSpace
 Independent Publishing Platform, 2018) (from German)

ANTHOLOGIES

To Woo and To Wed: Poets on Love & Marriage (editor) (The Poseidon
 Press, NY, 1992)

COMPILATIONS

Correcting The World: Selected Poetry and Prose of Michael Blumenthal
 (Legal Studies Forum, University of West Virginia, 2007; James R.
 Elkins, Editor)

TABLE OF CONTENTS

I. TRAVELS

II. STONE-HEARTED

III. DON'T DIE

IV. EPILOGUE:

"Though they be mad and dead as nails,
Heads of the characters hammer through daisies;
Break in the sun till the sun breaks down,
And death shall have no dominion."

Dylan Thomas, "*And Death Shall Have No Dominion*"

June, 2022

For Jill —
With admiration,
in memory of Stephen,

> "*Hide your God*, for as He is your strength,
> in that He is your greatest secret,
> He is your weakness as soon as others know him."

Paul Valery, *The Art of Poetry*

and with every
good wish —

I

TRAVELS

Book Buying

after Larkin

Just when I'm sure there's nothing going on
I step inside, letting the door blow closed
Another bookshop: toys, coffee, and scones
And, somewhere, books, it might well be supposed,
And mags, authors smiling from their covers
At the register, chocolates, cards and gum
And guilty pleasures, moving back and forth
Between the browsers and the would-be lovers.
As Jarrell knew, our lives are heading north.

I walk around, circling demi-gods
From previous lives, when syllables would sing
The passions of my youth? They now seem odd:
I hardly find a single blessed thing
I recognize, and so I genuflect in vain
And finally come to one: *On Being Blue*
And then, beside it, books on menopause
Then there's a lovely travel guide to Spain
I get the hint: my vocation's a lost cause.

Yet here I am: there's something lures me here
Although the slender volumes I once loved
Have both begun, and may yet, disappear.
I search below, beneath, and then above
There's nothing much to do but pay and leave

(no break)

14

Go home, watch TV. Nothing I hold dear's
Among what I've perused upon these shelves
There's not much point in staying here to grieve
I'll rest my faith among the gods and elves.

Nowhere *à la récherche du temps perdu*
How fortunate: I can at least escape
And leave. Or do the old soft shoe.
I look around. In the window, books on rape
And tattoos, cults, *Chicken Soup for the Soul*,
Crowd out the rest, short stories by Colette
Aren't here, or sonnets by Edna Millay.
But look! A book about the grassy knoll
From where, it's said, they shot young JFK.

I've spent an hour in this dark domain.
The croissant was delicious, that's for sure.
I bought a book on how to purge a stain:
Wise men have long observed that the impure
Is here on earth to keep the pure away.
And so I just move on. It starts to rain
As luck would have it, a green umbrella's
For sale beside the games that children play
I should thank God: I'm a lucky fella.

At last, I find a way out of this mall
I've bought an ancient *Diary of Anne Frank*.
And on my phone, a loud, insistent call

(no break)

Reminds me why I've turned into a crank.
I think I'll stop en route, go buy some booze
Then I'll be home, continue with my scrawls
Paper to pen, unconnected to the web
(These acts of mere resistance, what's the use?
There's not much hope for one who's no celeb.)

Strange, to think of ancient Homer tweeting,
Shakespeare on *Facebook*, nothing that consoles.
Offstage, I can hear the constant bleating
Of Orwell's futuristic sheep. I have no role.
Like the afflicted lining up at Lourdes,
I'm left to contemplate the gods' unseating,
Dream of salvation, succumb to dismay.
Like tulips floating in the icy fiords,
I need to find another god to whom to pray.

For a Friend, Whose Son Has Been
Admitted to an Institution

The dice-roll, and puckered lips, of the geneticists
and, with them, the unspeakable grief
for the now-madman circling about in your garden,
telling jokes to himself only he can understand
but he's your son, this seemingly crazy one
and the love of a mother's milk knows no end.

Not even the secure walls within which they have
placed him, complete with pretty girls as unfocused
as he is, can console you. No matter how many cookies
he may be served, they shall not be as lovingly made
as your own. And how shall he be released from this
madness, that has transmogrified such gifts
into the eerie laughter of midnight, wild hands
grasping for food like a starved animal?

Once he swam the length of the lake, bicycled
more miles than any sane man would have found fit,
as if the body could perfect itself into a refuge
for stray thoughts, as if the vessels through which
blood coursed could arrive at another station.

O mother, friend, neighbor, who now exits
these stairs leading from underground tunnels
onto sunny streets leading to cages for humans,

<div align="right">(no break)</div>

how shall a mother's love endure when a child leaps
into the unknown netherworld of his imaginings?
No training in bravery or kindness has prepared you
for this, the heart so heavy with its own offspring
that only some devious god must know how much
strangeness that heart can endure, or how much love.

Citizen of the World

I have spoken to the Ethiopian ambassador
about the increasing genocide in the Tigray region.
Earlier I talked with French President Macron
about the restrictions imposed on France's Muslims.
Late last night I got on the phone with Belarus
President Lukashenko, to whom I objected
about the reign of terror imposed on the opposition
and soon I will be on the line with President Erdogan
to let him know of my objections to the life sentences
for hundreds of coup leaders. I have also tried
unsuccessfully to reach Thai Prime Minister
Prayuth Chan-ocha to discuss his country's
lèse-majesté law, which makes insulting the king
punishable by years in prison. Tomorrow, once
he is off the golf course, I will call soon-to-be-ex-
President Trump to tell him what I think of his
pardoning the perjurers and criminals who made
his reign possible, and then, finally, I will call
my mother to wish her a Happy Thanksgiving,
and feel that I have done my duty to both home
and the world. After that, I will be able to take
a nap with a clear conscience. I will dream
of anemones and gardenias and simply listen
to the birds singing in my garden, without
a single thought as to what they are saying
or to whom, without asking myself why

(no break)

19

some of them seem to just be sitting there
on their branches, crying in their sleep.

Questions of Travel

Whether you came on foot, by train, or car
Whether you take the high road or the low
Things still remain exactly as they are

Some sit at tables, others at the bar
Some brightly lit by love's vague afterglow
Whether they came on foot, by train, or car

You played a birdie, your lover scored a par
You live in Paris, she lives in Bordeaux
Where things remain exactly as they are

She plays the flute, you strum on your guitar
She finds you sexy in your black *chapeau*
Although you came by train, and she by car

She'd hoped you'd turn into a movie star
Not just an extra in an old sideshow
But here are things: exactly as they are

She caught you staring at the cookie jar
And offered you a slice of her *gateau*
So sad, you think, the way things are
You wished you'd come by foot, and not so far

The Purpose of Falling in Love is to Love

No more the savage heat
of fuck-filled afternoons,
no more the mad grappling
against the sheets or forsaking
of all others, but now, instead,
the soft arpeggio of a happy descent,
the hand accidentally brushing against
an ear, the simmering vegetables
of afternoon, the scent of hair
on morning pillows. O love,
I was always trying to convince you
of this: pictures of lusty afternoons
needn't be forgotten, simply repasted
into the widening scrapbook
of early evening, which now
I must fill again with the one
with whom it began.

The Face of Carmen Basilio

I can still see his face, he who was known
as the Upstate Onion Farmer, left eye
swollen shut, lips bulging towards the nose,
swollen cheeks staring up from the cover
of the *New York Daily Mirror*, March 26, 1958,
the morning after Sugar Ray battered him
for fifteen rounds at the Chicago Coliseum.
His eye was shut by the seventh round—
in the photo, it resembled an octopus's back.
The announcer kept calling it 'quite a mouse'
and, finally, a 'small balloon.' By the end
of the fight, he was a contemporary Oedipus,
eye puffed to the size of a jumbo egg, dyed purple
and green, a pink slit where the lid had been cut,
so clearly of no use any longer that the crowd
merely gasped in horror and went, silently, home.
It was a bit like Escamillo beating up Don José,
as that other Carmen lay dead on stage. He
almost died that night, with his once-beautiful face
battered into silence, the audience speechless,
everything but the referee's scorecard on his side.

Happiness

This soft chair
in which I lie
this slight breeze
blowing through the acacia
and horse chestnut
the laundry
rippling on the line
and this cup of coffee
with milk and sugar
so sweet
the air itself
full of birdsong and promise
and this heart of mine
so content
with the mere thought of you
so at peace
knowing you are somewhere
anywhere
coming closer, closer
in this world
this beautiful, godly world
in which we live,
in which we're living now.

Breaking News

The news has spread
among the blackcaps, greater tits,
and nuthatches in the backyard
that there are fresh sunflower seeds
in the feeder, a brisk wind
blowing from the south.
Not a word about Donald Trump
has been uttered, not a syllable
about the markets. Even
the stark famines of the world
and the brutalized children
seem far away
from this happy illusion
that all is well with the world.
The sun is dappling
shadows against the grass.
The next war is already
beginning. A single leaf
falls silently to the ground.

Avalanche

after the film Force Majeure

If an avalanche should come
and we find ourselves sitting on the balcony
of some European resort, don't worry:
I promise not to grab my ski gloves
and cell phone and leave you there
I won't leave you in the hands
of fate, I won't rush, coward
though I am, to save my own skin
I will be there, taking the rush
of snow into my body
before it reaches you, unafraid
of the torrents life can bring
knowing, at last, what it can take away
how white and colorless this world
would be without you in it, how worthless
my phone, my gloves, my very life.

for Isabelle

Going to the Movies Alone

There will be no one to love tonight after *Selma*
when the credits have rolled and the lights undimmed
and I will come home to my defrosted pork chop
with canned apple sauce and our sweet cat Pilango
no doubt waiting for me in the driveway and I
will watch a bit of CNN—a recap of the O.J.
Simpson trial—before going to bed with a book
of essays and a small beakerful of Grand Marnier
and I will speculate about tomorrow's weather,
whether it will be snow or rain or some other wintry mix,
and I will think of my wife, now asleep in the small
French village of Reillane, and I will turn down
the heat to 65, stroke the cat goodnight, and take,
as I do every night, my three pillows—one for the head,
one between the knees, and one (the most important,
my "hugging pillow") against my body—and I will think
of the psychologist Winnicott, who said the ability
to be alone depends upon the knowledge someone is there,
and I will fall asleep, as the lucky and the blessed do,
with the kind of dreams in which Philip Roth shows up
at my birthday party and Leonard Cohen at my wedding,
and I will not be preoccupied with the meaning of my life,
I will leave the metaphysics to the metaphysicians
and the agnosticism to the agnostics, and I will imagine
that the credits are rolling, and the movie directed by me.

Life List

Anyone who has lived long enough
to spot the resplendent quetzal
or the blue-crowned motmot
and even survived to add
the blue morpho butterfly and the
mating dance of the long—tailed manakin
to their life list can number themselves
among the blessed of this earth, as do I
this New Year's, my wife sleeping
beside me and, back in West Virginia,
our two cats, no doubt resting peacefully
on the cat-sitter's couch, and the list
of all those I have ever loved still expanding
and every kind of weather containing
its own clemencies and inclemencies
and so, friends, we should suspend
all judgments, even for a day, we
should put down every field guide
and simply number ourselves lucky
to be here, on this mottled, complicated,
mysterious planet, and gaze for a moment
at whatever lies before us, and shower
all our attachments with praise, and call
our own name into the air, and be
grateful for every single syllable that
comes back, and love whatever

(no break)

we can. And then try harder—
And love what we can't.

Evening Music

If you pay attention in the early evening
you may hear the sounds of weeping and screaming
coming from your neighbors' houses.
You may hear angry syllables of dispute
and wails of disappointed love, you may hear
the impatient scolding of children, the clattering
of dishes in the sink, even a broken plate
or two, thrown in agony or rage, breaking
against the freshly-painted walls. There's
so much pain in the world: so many of us
have come together with the best intentions
and for the wrong reasons, only to find ourselves
screaming into the sunset, tightening our fingers
around whatever is available to express our anger.
But the sounds of happiness and love, so much
more difficult to arrive at, are quieter: a hand
moving gently up over a wife's hips in the night
to arrive at her hair, a breath offered up silently
against a shoulder, all that is speechless and better
than disappointment whispered into the pillows,
the eyes opening with the first light of morning
in praise that can find no words to speak its name.

Flawed Words and Stubborn Sounds

The imperfect is our paradise.
Note that, in this bitterness, delight,
Since the imperfect is so hot in us,
Lies in flawed words and stubborn sounds.
 Wallace Stevens, *"The Poems of Our Climate"*

There comes a time in a man's life
when the angels no longer sing to him,
perhaps because they have found other,
needier bodies to speak through,
perhaps because he himself has become
a kind of angel, tattered and imperfect,
who must learn to sing, now,
his own human music. He wakes,
shaking the night's dust from his
unwinged torso, encircled
not by visions, but by a woman,
a child, the day's divine and doddering duties
and small pleasures. *What has he done*
to deserve this? he wonders, he who
once dreamt himself part of divinity,
a saintly presence among his flesh-ridden brothers.
Yet sing is what, he still believes,
he was put here to do—even
a mere earthly song, composed
of waning flesh and still-turbulent blood,

(no break)

of loves he has not so much dreamt of but found:
flawed words and stubborn sounds
that sound only like this.

for Bruce Lewis

Ambition

It dies cell by cell
the way mold spreads over the top
of cheese or fog over a valley
in summer. You hardly notice it—
like the repeating dream
of your grandmother dead in the house
but unburied for years. Life goes on
as if it were the most natural thing
in the world-a corpse seated
in an old rocker among the living. Once
you rose, aflame with things you wanted
to do, sentences from unwritten novels
and poems meandering through nerves
like streams through a mountain village,
speeches to the Democratic Convention—
the first Jewish inaugural, pronounced
by an agnostic. What a laundry list of things
to be done! What a humongous hunger for entries
beneath your name, a veritable Wikipedia
of latent powers and trophies to place on your shelves.
Still, there's not much nostalgia for those times.
Today, a bird you have yet no name for
came to the feeder, its beak greased with suet
you bought at The Dollar Store
on an aimless afternoon. It gave you pleasure
seeing him there, just as it did the cat,

(no break)

roused into alertness by the flutter of wings,
ambitious to play, then eat. You've still got
years left, you know, but it fills you with
contentment, only a little regret. *So what
if once you wanted to set the world on fire?*
And now simply a match.

For My Son, off to Africa

Now you will go and do
what I would have done
had I had myself for a father
you will go off into a world
of elephants and primates
into a world of wildebeests
and polecats and lechwes
you will come face to face
with the greater kudu
and the white rhinoceros
perhaps even the brown greater galago
and when you come across
Lichtenstein's hartebeest
or a morhol bushbaby
you must promise me
you will take a picture of them
for your aging father
you will do as all sons must
to outdistance their paternity
and channel their father's dreams
into his son's reality, you will
become a better man than I ever was,
holding the hand of your beloved
and of this beautiful world and walk out
brazenly into the African sunset

(no break)

and tell them all I have sent you.
Tell them your father says hello.

Liftoff

I remember being in the air with you
above the Gulf waters in Fort Myers
and how good it felt, to behold
the world below with you at my side
only air beneath our feet and a wind
of our own making, fish cruising
in the waters below us, the faint hum
of the boat's engine below, and your
blond hair blowing into my face,
your hand on my thigh. I remember
how good it felt to be in the world, yet
slightly above it, how you had snuck off
to buy the tickets, knowing it would
please me to fly off with you a bit
into the stratosphere, and how it took
our minds off everything terrestrial
as if there could be only love in the air,
a world entirely our own, no one
to remind us of what awaited us below,
when we would finally return to earth,
and of who we were, and what we might
have become, at least in a world with
nothing beneath our feet but dreams
and air, and never any solid ground.

Laziness

I could probably have run
two more miles, or swum
twenty more laps, no doubt
I could have written more books
or longer ones, at least ones
with more pages, or longer lines
or more lines to the page. Surely
I was guilty of being a man
who spent too long in bed with his coffee,
who dressed slowly and could sit in a chair
for hours in the sun, contemplating
the world of action and significance.
I was not the man my c.v. suggested
I could become O forgive me
those who expected more of me
as I sometimes did of myself
there was so much more to do
so much more that might have been done
but I was slow on the uptake, prone
to remaining prone for too long
a disappointment to all those who
voted me Most Likely to Succeed.
But I did little harm, I ran as far as
my ambivalent nature would take me,
did as many pushups as a deep sense
of inertia allowed, but here I am again,

(no break)

nonetheless, filling this page, eager
to make those of you who are more industrious
than I am happy, yet indolent as a sloth,
an animal I have always loved, one
I took into my arms in Costa Rica
before retiring back into my hammock
before filling the rest of the page
with words like these, only for you.

Cohabitation

Because the funny and the sad
must live together in the same house
like two distant tribes
forced to inhabit the same state,
because they will inevitably wander
into each other's rooms
like children with no real sense
of their own territory
picking up each other's toys
messing with each other's homework
each thinking they have nothing
to offer the other but the pleasure
of intruding on the other's territory,
you may need a house large enough
so that both can live peaceably–
one perhaps in the study, the other
in the basement, hardly a sound
passing between them. But sometimes
late at night, they'll meet in the kitchen
having come for a snack. They stare
at each other in front of the refrigerator.
You too? says Funny. *Yeah, me too,* says Sad.
There's not much room at the kitchen table,
but each takes a chair and sits down. *Nice night,*
says Funny. *If night's your kind of thing,*
replies Sad. *Frankly, it gives me the blues.* Funny

(no break)

has made himself a bagel with cream cheese.
Sad munches on some stale bread.
He's been downstairs listening to Prokofiev,
poor him. *Cream cheese?* asks Funny. *Nope,
I like it plain,* replies Sad. Beyond that,
there's not much conversation between them.
Even Funny's tired by now. After all, he's
been laughing all day. *I'm turning in,* he says,
taking a last bite of his bagel. *Me too,
says Sad, not much worth staying up for.*
But the house has only one bedroom, with
a small double bed. *You first,* says Sad,
I've gotta go pee. By the time he returns,
Funny's snoring in his sleep. *What the hell?*
Sad thinks, climbing under the covers,—
What the hell: it's only sleep.

Marriage

for Greg & Verena Sava

The small domestic details of a life
The garbage bin, the sink, the dirty bowls
Are what cement the bond of man and wife

The butter dish, the garden, the bread knife
Are what ensure the daily is made whole
Those small domestic details of a life

These stewed tomatoes, quite immune to strife
Might seem unworthy as the day's pure goal
Though they cement the bond of man and wife

The potted plants, the purple of loosestrife
Are not impassioned, yet they still console
Embodying the small details of life

The conflicts with which marriages are rife
Can soil the spirit and fatigue the soul
Without the glue that binds a man and wife

Our restless yearnings for an afterlife
Are not the kind of stuff that makes us whole
Better praise what binds a man and wife—
Those small delicious details of a life

II

STONE-HEARTED

Stone-Hearted

I like working at a university where
there's a building called *Mineral Industries*
and another called *Pharmaceutical Studies.*

It assures me there won't be too much poetry
around, that I can wake and say to my beloved,
"Hey, let's go check out some coal" instead of

How do I love thee? Let me count the ways.
It assures me I won't have my heart battered
by too much sentiment, that I'll be able

To live in peace with my private gods,
with only a few miners and pharmacists
to disturb me. Don't get me wrong:

I like poetry well enough, I just want to
keep it a private matter. Yesterday I went
to the drugstore, then visited a mine.

There was something poetic about it all.
Today, no one harassing me with a sonnet
of their own, I may write one myself,

Fourteen lines rhyming *abab*, and let the
last two lines go wherever life takes them.
Who knows? Maybe my poem will end

With the words *bauxite*, or *gneiss*. But
if not, what the hell?—*Aspirin* will do.

My Lover Lives Upstairs in Number Six

My lover lives upstairs in number six.
She comes down nightly for a dose of love.
There are the sundry things we try to fix

Right here in number three. I have some tricks
For women who descend from high above.
My lover comes downstairs from number six.

She's not that interested in pickup sticks
She's rather help me with my rubber glove
And with some things that she would like to fix

About me, so she adds them to the mix
And leans back, as I tenderly remove
The garments from my girl in number six

Who lives alone, and loves those dirty tricks
I administer for pleasure, just to prove
That there are things that only I can fix

The rest is clear: Two tenants get their kicks
Beneath the sheets, where push will come to shove
How sweet, the little ways that we can fix
My lover's life, who lives in number six.

Slip

She meant to write "my *fiancé*,"
but instead wrote "my *finance*,"
and who knows, really, what her fingers
were thinking? Love and money,
such contraries in the minds of moralists,
and yet why not mix them up a little,
why not let the unconscious have its way
from time to time, so that a cigar
is not merely a cigar and "I *love* you"
easily becomes "I *glove* you," just as,
in German, the words for *shooting* and
shitting are easily confused. Surely
she loves her fiancé as well as anyone
so what if he's got a little money
in the bank, *so what* if he *gloves* her
from time to time, it's all part of the
muddled package of mind and heart,
all part of the dirty little secrets we reveal
as our hands jump over the keys, as our lips
form around words, and the wrong word—
or was it the right one?—emerges from its sleep
to remind us who we are, to remind us
that even the fingers dancing over the keyboard
will occasionally slip, even they, with a
drink or two, are liable to say what they
really mean, by accident, in all sincerity.

At the Feminist Passover Seder

The Jewish Labor Federation Haggadah

I had long ago made peace with a female God
and, not without a certain pleasure, the possibility
of the woman on top, nor did it bother me
to hear about oppression of the workers, sexism,
ethnic cleansing, corporate greed and the like
in addition to the usual boils, hailstones, famine
and locusts. I knew, of course, how badly
we had treated the Japanese during the War
and that we had discriminated against others
on the basis of class, race, gender and sexual
persuasion. There was certainly nothing wrong
with contemplating social justice between
the matzo ball soup and the gefilte fish
and I didn't even mind a brief mention
of Martin Luther King and Gandhi—why not
let the *goyim* have their say too?—along with
the bitter herbs and the Manischewitz wine.
So what if _____ wasn't my favorite poet?
She, too, deserved a place at the table, and a poem
or two between the *karpas* and roasted shank bone
seemed reasonable enough. (After all, I had spent
eight hours, as instructed, baking the roasted eggs
in their strange brew of coffee grounds, onion skins
and vinegar—so why not be generous now?) Soaked
with sobriety I downed the fourth cup of wine,

(no break)

only to find that the messenger Elijah, once again, had failed to make an appearance. *If this is the way to celebrate the flight from Egypt,* I thought to myself, *I'd rather go back.* By now, I had little appetite left for anything, but when the chocolate mousse— prepared by an unrepentant capitalist and supporter of the war in Iraq— finally appeared, I dug right in, hiding a hard-on beneath my napkin. At last I was overjoyed to have escaped from Egypt, and to have emerged, bone-dry, from the freshly-parted sea.

Hypocrisy

I wonder what small animal had to die
so I could buy this leather belt
for a mere 1,500 forints from the street vendor
near the Lukacs Baths here in Budapest
I wonder how much it had to suffer
before its flesh was served with good wine
in some elegant restaurant and its skin
made into belts and purses
for people like me, too comfortable
in their hypocrisy to resist a good buy
at a bargain price, too remote
from the slaughter and suffering
to do anything about it, too happy
at how good their new belt looks
with the black pants made in China
by underpaid factory workers O Lord
how uncomfortable it makes us
to look too closely at the way things are
how much easier merely to tighten
the belt another notch, chew slowly
on the veal marsala at the Italian restaurant
right next to the vegan one O Lord
I am afraid I am not a good man,
at least no better than most of my brethren
on this damaged earth, the scent of meat
and leather everywhere and so peaceful

(no break)

the sleep of those like me, in whose name
the animals have suffered and died,
in whose name I can say *dear God forgive us*
we knew what we were doing
and did it anyway.

Love, Falling in Love

When you fall in love
two become one.
It's delicious, almost
as good as dying.
Each folds his wings
and hangs, like a bat in a dark cave,
making sweet sounds, blind
to all but the scent of the other.
It can go on this way, to be sure,
as if two wills had bent outwards
to unlearn their own language,
tongued like a Pentecostal priest.
But then, just as you begin
to feel good in the other's skin,
you cleave like an amaryllis
and one becomes two once again,
the one with a bad cold, the other
humming a salsa tune to himself
with no one to dance with. It's
great, waking together, until,
like Gregor Samsa, you realize
you now have six legs, all
trying to walk in the same direction.
O love, don't you recognize me?
I'm the one who was so spectacular,
just the other day. Love's not a dream,

(no break)

nor is falling in love, but now
the three of us must find a home,
a single roof beneath which we can live,
a beast of burden, a long-legged man
escaping from prison on a very small horse.

Claudius at Yom Kippur

"My words fly up, my thoughts remain below:
Words without thoughts never to heaven go."
Hamlet, III.III

My words flew up, my thoughts remained below
Between Cantor Kornfeld and Rabbi Strauss
My father told me that I had to go

I had my doubts, though others seemed to know
I was the infidel, still facing south
My words flew up, my thoughts remained below

I'd been forewarned: We reap all that we sow
Why was I here? No songs came to my mouth
My father told me that I had to go

My stomach growled, like all those in my row
The aging daveners, the restless youth
My words flew up. My thoughts remained below.

We sang *Kol Nidre*—those above, below
Who found it holy, others quite uncouth
My father told me that I had to go

That rocking motion moved me to and fro
To soothe the sinner and the angel both
My father told me that I had to go
My words flew up—Why were my thoughts below?

Orgasms

Some of us have many
Others few
Some are quite content
With one or two

Some can make beds tremble
Or else just shake
Others aren't enough
To keep their hosts awake

No matter how you have them
They can be
A small glimpse of
The soul's eternity

Planted in the body
Just to show
How much flesh knows of divinity
That soul can't show

Cruelty

I remember only that his name was Chris.
He had one brown eye, and one blue eye
and, one day in Mr. Orange's 5th grade class,
someone discovered it, and yelled out: "Hey,
Chris has a blue eye and a brown eye!"
Then, when recess came, we chased him
around the schoolyard, each of us, with
our matching pairs of brown or blue eyes,
wanting to verify the rumor for themselves.
He must have been frightened, embarrassed,
dismayed that his secret had been exposed
for all to see, for he kept running away from us,
he kept moving, his face to the chain-
link fence, trying to keep us from seeing
those Janus-faced eyes of his, until, at
last, I remember he turned towards us,
he had run out of room in the yard into which
to retreat, and I remember thinking that, now,
with both his eyes, his brown one and his
blue one, he could finally see us clearly.

Geese

for Lynn Freed

When the Germans beat their geese
into honking at Auschwitz so as not
to allow the cries of children on their way
to the gas chambers to be heard, they made
a strategic decision. Like generals,
they decided it wasn't enough
to gas the children, but that the geese, too
(both the Jewish and non-Jewish ones)
had to be punished, they decided to let one
suffering drown out the other, creating
a kind of hierarchy. There were no bird guides
available to those listening, it might just as well
have been joyful honks the geese were uttering,
after all it was spring, the daffodils were out,
the children marching toward their destinies,
all was right in the world, if only you didn't listen
to what was below the surface, if only you
didn't hear the honking, then the silence after.

It Was a Joy to Love You for a While

It was a joy to love you for a while
You came to me at night and it was good
The room was lit up by your very smile
It was a joy to love you for a while

It was a joy to love you for a while
Things were written clearly as love should
We made the rafters shake with special style
It was a joy to love you for a while

It was a joy to love you for a while
We were the gossip of the neighborhood
We gave no thought to trick or guile
It was a joy to love you for a while

It was a joy to love you for a while
Your touch would put me in that special mood
We traded fluids, largely without bile
It was a joy to love you for a while

It was a joy to love you for a while
I kissed the ground whereon you stood
We never thought we could revile
It was a joy to love you for a while

It was a joy to love you for a while
But now that joy seems gone for good
I've put your clothing in a tidy pile
It was a joy to love you. For a while.

Freedom

Budapest
July, 2015

I must confess I have taken a second croissant
from the table marked *one coffee one croissant*
at the old socialist Erzsebet Hotel
here on Kiraly Mihaly utca in Budapest
and that the second one tasted even better
than the first; all this after watching
the Communist-era film *Witness* about
Communist dike worker József Pelikán,
anonymously accused of slaughtering
a pig for food, and after a few glasses
of good Hungarian wine at Beckett's Pub,
the wine much more expensive—and better—
than when I first came here in 1986, the street
filled with expensive restaurants of all sorts,
the women still as sexy and beautiful
as I remember them back then, when an hour
with a prostitute cost little more than a glass of wine
and everyone was looking for freedom of some sort,
as I was this morning with my second croissant
which I can still taste in my mouth, all buttery,
perfect and quickly digested, like freedom itself.

The Words

If you tell someone you love them
you will give them power
over the sun and moon,
you will give them power
over many of your appetites
and how they are satisfied,
over the flowers that decorate your window sill,
even over the contents
of your refrigerator,
you will give them power
over the scent of your sheets
and how often you need to change them,
power over the motes of dust
that settle, or fail to,
on certain shelves and night tables
you will give them power
over the color of your socks
power over your very breathing,
its regularities and irregularities,
the missed beats of your heart.
Yes, if you tell someone you love them
there is much to be relinquished,
so very much that your own shoes
will no longer stand still
in their closets, your clothes
will no longer fit your own body

(no break)

and your tissue box will be quivering
on the night table, awaiting your tears.

Ten Couplets Against Modernity

Soon pen and paper will have gone the way
Of Boris Yeltsin and Teresa May

The sounds we once considered merely noise
Are now the center of our equipoise

The selfie and the email and the tweet
Are the rotten fruit we now must eat

What we once considered masturbation
Is what now passes for communication

The man who merely said *hello* in passing
Is now accused of sexual harassing

They fell in love for sure in cyberspace
It hardly matters that he didn't see her face

The book I've read on Kindle's all the rage
Although my fingers couldn't even turn the page

Sexting and texting on Instagram and Twitter
He fell in love with the babysitter

The photo that you'll find on Photoshop
Is the miracle that made my aging stop

The things they've learned on social media
Have long replaced encyclopedias

If All These People Want to Make the World a Better Place, Why Isn't It a Better Place?

There must be some people
who are not on TV tonight
and who are sitting at home
far from the cameras and journalists
figuring out how to fuck things up,
how to fill the air with carbon dioxide
and the airwaves with noise,
there must be some people
working away in the quiet of their living rooms
who do not have our best intentions at heart
who will total up their profits and losses
to arrive at some unconscionable figure,
there must be some people out there somewhere
who are not going to make TIME Magazine's list
of our 100 most spectacular citizens,
who are beating up on their children
and spouses, not recycling their garbage,
leaving their porch lights on all night,
who are not driving electric vehicles
or even hybrids, and who are eating
the freshly slaughtered pigs and chickens
from factory farms, savoring the *foie gras*
produced by gavage feeding of tortured
geese and ducks, there must be some people
talking only to Alexa or Siri in their lonely

(no break)

living rooms, there must be some people
who are unkind to panhandlers and the homeless
O there must be a whole lot of bad shit
going on if all those good people are out there
making so much noise and we're still
left with what we've got and Trump
is still President, and God is up there
somewhere still looking for a home.

Yin and Yang

The other woman
was noisily beautiful, athletic
to a fault, a fount
of perpetual laughter and good cheer.
In a gathering of any kind, light
shone down on her as if
she were on stage, the only thing
waiting was for her to burst out
in song, or bring out
her pet boa constrictor for show
and tell. A trophy girl
if there ever was one, her hair
cried out brightly for more fun
and the small extra poundage
on her thighs was just enough
to keep a man satisfied, but never
hungry, never out in the cold.

The wife, on the other hand,
was beautiful in the lowest of registers,
you almost needed to look twice
to notice her, and then
that white hair and thinness
might have made her look older
than she truly was. Amongst flowers
or vegetables in the garden,

(no break)

however, she took on a glow
like Demeter, and corn grew
in exuberant stalks before her.
No one could call her
the life of the party, but, if
there was no party, life
blossomed forth from her
quietly, often in the dark.
With each of them
he felt the happiness and sadness
of true love, he knew
he needed something of each,
though what each wanted of him
often seemed a mystery, one
he was content to leave undiscovered
just as long as he could have them both,
just as long as the sun set somewhere
upon the large bed in which he lay,
one arm reaching out for beauty,
the other for beauty of another kind.

This Fraught Straining to Be Good

for Stephen Dunn

So terribly hard to be virtuous, isn't it?
And yet, wherever we turn,
so many examples: civic leaders

and committeemen (even the President!)
holding hands with their wives,
so many portraits of loving parents.

Yet virtue, of course, is complicated—
why, after all, would so many
pontificate about it if it came so easily?

Once, I was virtuous all by myself,
by a beautiful stream in spring.
Not even a bird applauded.

Then, I was decent again, in the dark
with a young girl not my wife.
I wasn't married at the time, and,

though no one clapped, she,
at least, seemed happy, and no one
was the worse for it. Now,

though, virtue's more elusive (wives,
children, so many possible betrayals),
a subject for poetry and sleeplessness,

and as I sit here in the dark, dreaming
of my faraway lover, toward whom
everything virtuous in me strains,

I could tell you how fraught I am,
how easily flesh encloses around flesh,
and how difficult it is to sing

to a single body the soul's complex
and irreverent song, its desires
so rapturous in the dark, so wild

and unethical, so filled with
unnameable virtues, untameable cries.

Good-Bye Villanelle to the Age of Trump

How do you say good-bye to one you hate?
How do you tell him you're so glad he's gone?
That man now passing through the White House gate.

He's gone at last, a good four years too late
A man immune to kindness, with a frown
How do you say good-bye to one you hate?

It's time to leave him to his sorry fate
He rose way up, and now he's going down
And we can say good-bye to one we hate

Satan, too, was looking for a mate
One whose hair was orange, like a clown
He's there now, passing through the White House gate.

He could have died of Covid, overweight
We would have had to set him in the ground
Not quite the right farewell for one we hate

Four years enough–thank God it wasn't eight!
We've sent him packing to another town
That man who's passing through the White House gate
Hello to love. At last: Good-bye to hate.

III

DON'T DIE

It Happens

It happened to him, it happened to her
It happens to animals, plants and the sea
It wasn't supposed to happen to me

It happens to birds and it happens to trees
It happened to Grandpa, it happened to Sue
But it was never supposed to happen to you

It happened to Gerald Ford, and Carter too
It happens to all those who still want to be
But who would have thought it would happen to me?

It happens to nightingales, and swallows too
It happens to bonobos, and to the bees
You never imagined it would happen to you

I knew them as children, as middle-aged too
My friends now on crutches, in Room 33
I never imagined it would happen to me

O well, that's the cycle, our own trinity
From youth to old age, with some middling there too
It happens to all of us, just let it be
It will happen to you, friends. It happened to me.

Sitting Around

Now I have come to the place
in this life where what I do most
is sitting around. There is much
to be said for it, though you
will never know until your own
time has come, believe me.
I am not re-reading *Anna Karenina*
or *War and Peace*, I am not trying
to write the sonnet to end all sonnets
or the last great villanelle. No more
love letters to imaginary lovers,
no more imitations of Mick Jagger
singing *Beast of Burden* before the full-length
bedroom mirror. The word for swallows
in Hungarian is *fecskék* and they are what I saw
this evening while just sitting around,
them and the whitish-yellow sky
across the yard this very minute
and no pain anywhere in my usually
aching body, and the mourning dove
wishing me good-night as it watches me
sitting here on this mid-summer evening,
not all that exciting an event in the life
of most, but grateful, at least,
to still be around.

A Crack in Everything

> *Ring the bells that still can ring*
> *Forget your perfect offering*
> *There is a crack in everything*
> *That's how the light gets in.*
>
> Leonard Cohen, *"Anthem"*

There is, it's said, a crack in everything:
The love that's perfect, and the meal that's made
That's how the light, and then the dark, gets in

A bird grows silent, though birds can sing
The bills are on the table, must be paid
There is, we know, a crack in everything

The eager songs that too much lust can bring
Are sung too soon, and cannot be delayed
That's how the light, and then the dark, gets in

For every queen, there must have been a king
Who ruled the realm, until he got waylaid
And found, alas, a crack in everything

That can't be mended merely with a ring
Though vows exchange, and promises are made
That's how the light, and then the dark, gets in

I'm not so young: I don't talk on the wing
The thoughts that fall from me are not displayed
That's how the light, and then the dark, gets in
There is, I've learned, a crack. In everything.

Just Life

The man whose son's brain
has been virtually eviscerated
by shrapnel in Iraq and who's been
reduced to a caregiver 24/7 says
it's just life that it's happened this way
he says *it's just life,* as does the woman
whose schizoid son has just been admitted
to an institution, the man trembling
with Parkinson's disease, the quadriplegic
wrestling his way to the Special Olympics,
all these heroic ones saying *it's just life,*
and I can't help but wonder what I would say
in their position, I can't help but wonder
what I, with my intact limbs and lack of nobility,
would say. Would I say *O poor me,* would I
grin and bear it like Job, or would I cry out
with Luke: *Will not God bring about justice*
for his closest ones.... Will he keep putting them off?
Would I complain, wail, beat my chest,
bury my head in the sand, or would I
align myself, amid all these blessings,
with those nobler than I am, gaze up
at the moon, at everything I have ever loved,
and say: Not a *just* life, *just life.*

Calling My Dead Friends

Yesterday I called Saki and Charlie and Adam
and John on their cell phones, though
they are gone, just to hear again
the sound of their voices, the way I might
listen to an old Bix Beiderbecke record
or watch a film with Hedy Lamarr. It felt
good just to hear them again, as though
they were speaking to me through
some technological haze, a bit the way I feel
listening to the 50-year-old recording of my
grandmother giving me advice as I left
for college. *You have to be choosy with
your friends, she said, show me with whom
you travel, and I'll show you who you are.*
I took her advice, choosing the likes of Saki,
Charlie, Adam and John, which is why I love
hearing their voices again, as though saying:
no one is ever dead, no one will ever leave.
I hope someone will keep my voice on the tape
long after I'm gone, so that those who loved me
can call anytime, so that they too can listen
to my voice as if I were still here, as if I were
still calling out to all those who miss me enough
to keep calling—even now, even here.

He Waited

In memoriam, R.L.S.

He waited, as he put it, until
this experiment was done,
being a scientist at heart,
he waited until he still knew himself
and those he loved, he waited
until the sky was still the sky,
the hills the hills, the lake the lake.
We will not and cannot, he wrote,
allow ourselves to lose who we are.
Who he was: a sweet and gentle man,
himself until the very last moment,
himself until he felt himself at the edge
of being no longer himself. He waited
until he had emptied all his kindness
into the world, and the world had spoken
back. He waited until the light came.
He waited until, at last, there was
nothing, absolutely nothing, left
to wait for. And then he died.

How Not to Die

Diet is a good place to begin
Then exercise, of course,
And as much love
As you are capable of, spread
In as many directions as possible
Sex, too, is a good thing,
Especially when accompanied by tenderness
And generosity
And don't forget the weather—
All kinds, inclement and otherwise.
Learn to love the rain, the sleet,
The vast asymmetry of the stars
If someone speaks badly of you,
Kiss them many times
Until they are breathless.
And if you are betrayed
By a friend or a lover
Bake cookies for them, cakes
Dip their noses in the bright peonies
That have just emerged in your garden
Try hard to pretend
That Donald Trump is not President
Of the United States. Imagine instead
It is Nelson Mandela
Or a distant cousin from Kiev
Dream hard, wake in the middle of the night

(no break)

And write them down
Then read them to the first bird
That arrives at your feeder
If you are hungry for things
That are not good for you
Eat them anyway, then repent
By giving your dog a big kiss
On the mouth. Clothes
That no longer fit you
Should be cut up
And fashioned into abstract collages
Food that has gone bad in the frig
Should be left there
In perpetual hope of resurrection
Make long lists
Of everyone who has ever hurt you
Then crumple them up
And roast marshmallows with them
Or else pork fat on toast
Pretend, now, that you will live
Forever, put your arms around
Every self-help book you have ever bought
And read it aloud to the grass
Then pray for rain
Watch it grow

Blood

When Rui Urayama's fingers began to bleed
while performing Bartok's Piano Sonata BB 88
at the Cincinnati World Piano Competition,
she just kept on playing, she played
right on through the *Allegro moderato* and then
the *Sostenuto e pesante* and the *Allegro molto,*
she played on through the dissonance of the
piece itself, using the piano
in so percussive a fashion that her fingers
bled more and more, until the keyboard
was covered with blood, like a child's handkerchief
after a bloody nose, until a technician had to be called
to clean off the keys, but it didn't matter to her,
she said "it didn't hurt, really" and so she kept on,
bleeding for beauty and art as so many have bled
before her, as so many trying to make the world
even more beautiful must bleed in the privacy
of ateliers and studies, must bleed at their windows
looking out over the golden-yellow leaves of
the marvelous gingkos and the rust-red underparts
of the chaffinches and robins, they who have bled
privately in their cubicles of paint, ink, keyboard
and gut, without even getting up to take a bow
until the bleeding is over, and no audience left
to admire their courage, with only the technician,
summoned from the anonymity of some basement

(no break)

to clean up their mess, to wipe the slate clean
for the next performer, like a raptor soaring
over a ravaged battlefield, a breeze.

Not Not

in memoriam, C.K. Williams
(Dying / Not Dying)*

We knew, of course, which title
would triumph in the end,
like a multiple-choice exam
where the correct answer
is always *all of the above*. Transfusions
only postponed the inevitable,
prognosis was exactly that:
that which came *before* knowledge.
Each week your strong, raspy voice
grew dimmer, each week poetry
(which, indeed, could make
nothing happen) mattered less
until, finally, just days before
your title would be diminished
by half, I asked, "*Who's there
with you?*" and you answered:
the last word I would ever
hear you speak: *nurses.*

*working title of C.K. Williams' manuscript-in-progress,
which he was still working on when he died.

And That Will Be That

*"Soon I will be forty, and when I'm forty, it won't be long
before I'm fifty. And when I'm fifty, it won't be long before
I'm sixty. And when I'm sixty, it won't be long before I'm
seventy. And that will be that."*

Karl Ove Knausgaard, My *Struggle*

Just because I am here in this water aerobics class
at the Palm Green Retirement Community
in Del Ray Beach, Florida with a group of
twenty-five mostly Jewish women in their seventies
doesn't mean there's no more lust in my heart
or that I have given up on the idea of eternity,
it only means that I am slowly making peace
with the exigencies of my own body, this rusted
chassis filled with spare metallic parts, that I am
a kind of bionic man, doing jumping jacks and
tracing the numbers from one to ten with my toes,
singing O *beautiful for spacious skies, for amber waves
of grain* along with Hedda and Monica and Doris
and Jeanne, trying to control my bladder long enough
not to pee in the pool, reminding myself that at least
I am not a widow or a widower, that my feet are still
touching the bottom of this pool, that I could still
swallow whatever medications I have taken
this morning without assistance, that I am of

(no break)

sound mind, and the grunting sounds I make
whenever I move are the syllables of the living,
and that there are remarkable orchids all over
the place, anhingas and moorhens feeding their young
in the trees of Wakodahatchee Wetlands, along with
wood storks, green herons, egrets and—if you are
truly among the blessed—roseate spoonbills, and that
there are just ten minutes to go in this comi-tragedy
of growing old, just ten minutes before I draw circles
with my shoulders for the last time, then burst out
singing with Helene and Monica and Melanie and
Ruth: *America! America! God shed His grace on thee,*
and then go home, and then go back to sleep.

You Woke Twice

for Laszlo Kunos
& in memory of Gabriela Fekete (1948-2018)

You went to sleep that night
as you had for fifty years
so entwined by habit and the familiar
it hardly mattered
she was only a shell of herself,
that soon you would be sleeping alone
with only memory and gratitude
to guide you, only the echo
of her footsteps leading you to sleep.
You woke twice during the night,
you woke twice and heard
her barely audible breathing,
mimicking your own. Then, finally,
you woke a third time, but the room
was silent, terribly silent, as if
she had snuck out during the night
so as not to disturb you, as if she had gone
to a secret place only she had the key to.
You woke and, amid that resonant silence,
there was only one sound left in the room—
the one you had been dreading for so long:
the sound of your solitary self, still breathing.

Parable of Aging

When I was a young man
and people asked
what time I got up, I'd smile
and, pointing downward,
say, "*He* gets up at five-thirty...
I get up at six."

Now, when people ask
the same question,
I still point downward,
but I reply: "*I*
get up at five-thirty.
He sleeps all day."

Train Stations at Night

They are sad and lonely places,
filled with those who should be home
with someone they love, beside
a warm fire, with a glass of wine
and a small prayer of gratitude
but who are here instead
waiting for a train to somewhere
more hopeful than where they are, somewhere
with perfect stars and monuments
to uncertainty and movement. Yes, they are
all gathered here, in their winter coats
exhaling circles of smoke into the night air
and looking up at the timetable
of departures and arrivals for the track
from which they, too, will depart,
making do with the brief intimacies
of conductors and fellow passengers,
hoping they are headed in the right direction,
petitioning night for morning's arrival
at the place they had wanted to be at
to begin with, in the consoling arms of one
they should never have left, and who alone
can welcome them home again.

At the Funeral of My Friend George Konrad

What are you doing inside that box,
dear friend? What are you doing there,
dissident-in-residence, man of a thousand smiles,
visitor in your own country? A small flotilla
of rabbis surrounds you, here in yet
another Jewish ghetto, much like the ghetto
you hid in as they were shot into the Danube.
Now, you are surrounded again
by lapsed Jews of all sorts, fellow scribes,
five children, two wives, countless neighbors,
friends, admirers of all sorts. But, still,
what are you doing inside that box?
Twenty-six years ago, we met in the bar
on the 15th floor of the Hotel Budapest,
you talking as usual to someone with a
tape recorder and pen, eager to share your wisdom.
I, too, was eager to share your wisdom—stories
of the famous and unknown, so many lives
squeezed into a single life. "A man's life
is nothing," your father said as he lay dying,
but your life was something, your life
was special. Now they will bury you in the earth,
where you once buried your own manuscripts,
as if reuniting you with your
own words. But you will not be alone: *Ady Babits*
Faludy Fejtö Jokai József Kisfaludy Kosztolányi

(no break)

Krúdy Lukács Móricz Radnóti Szerb Vörösmarty
are all there with you. Still, it is hard for me
to understand what you are doing inside that box,
since no box is big enough no box could be
big enough no box will ever be big enough
to take your massive spirit from this earth.

Farkasréti temetö 22 Sept 2019

Infirmity

Now that I will never chase
a tennis ball again
and, in all likelihood,
not women either,
I will have to do something
with my more primitive instincts
I will need to re-channel my energies
toward something that requires
neither movement nor sex appeal
I may even try cooking
and gardening, I may become
a more contemplative human being
I may do more to advance the fate
of my species, who knows
but that I may discover some
hidden talents I long harbored
but made little use of
maybe even poetry will emerge
from my infirmity, the Muse
may decide she prefers those
who spend most of their time
sitting in chairs, merely gazing
out into the world, I may even
start writing a blog, or sending
my poems out into the world
on Facebook, enough of snobbery

(no break)

enough of the mortal combat
between high and low culture
enough of chasing so many things
enough of everything but this.

Transitional

It was not so much that we'd lost interest
in sex, but that sex lost interest in us.
The body found it had other things
to do: synapses misfiring, joints
worn thin with careless usage,
even the good old hippocampus
not quite able to remember where
it had placed the keys, or the name
of its best friend. Such were the ways
of our decline, like that of the blue Twingo
parked in our yard all these years,
the door handle now fallen off, gears
grinding away with each shift. Yes,
we're here, on the downward slope
and many a night can be spent
chronicling those small amorous victories
and defeats, those long-ago nights
when the body seemed to know
exactly what it was doing, when pleasure
seemed only the right caress away
and we didn't yet know what it was like
to wake mornings, trying to remember
that one good dream, trying not to notice
the many places the body now hurt
and simply remember what it could do
in old times, before all the little accidents

had taken place, before we woke and,
instead of reaching for her, reached
for the bottle, the better living through
chemistry that had now become ours
and would keep us, we imagined, in
good enough shape to arrive at our new
destination, our newly revised hopes.

Brodsky, Walcott, Heaney, Harry and Me

Cambridge, 1984

It was 1984. They were all still alive,
none had yet won the Nobel. I was 35,
forever humming the Talking Heads' line
How did I get here? as I walked
through Harvard Square. We all
ordered hamburgers. My friend Harry,
Joseph's translator, was there too, just
to keep things human. I don't remember
much of what we talked about— or, rather,
they talked, we listened. I remember
they were wild about Tuckerman's Sonnets,
which I had never heard of. When I got home,
I looked them up, filled with cedars and hemlocks.
One line struck me most of all: *And change,*
With hurried hand, has swept these scenes.

It's 2020 now. Change, with hurried hand,
has swept that scene. All three of them
are gone, their Nobel Prizes gone with them.
Only Harry and I are still here, feet on the ground,
no prizes to speak of. And Tuckerman, too,
is long gone from that day, from the rain
drumming outside and none of us knowing
what was to come, or by whose hand.

You Can't Have Your Cake and Eat It Too

It was a good night all around:
Plenty of frivolity, good food,
music that was amateurish but fun
everyone seeming to like one another
even beyond the usual hugs
and pecks on the cheek. One birthday
is as good as another, but
what the hell, this was 64,
edging towards the end of mid-life
when almost anything you can bring to the table
is worth eating, any cause for merriment
worth celebrating. The guest of honor
walked in, along with his wife and daughter,
and the guests, who were supposed to be
a big surprise, rose to applaud,
chanting his name. Here we were,
an ordinary evening in Morgantown,
no one particularly rich or famous,
or even beautiful, but more than enough
for anyone who knows how wonderful
the quotidian is, how blessed are they
without chronic pain or crazed children.
But then the cake came—German chocolate
with coconut pecan frosting—and it was
too much of a good thing, no one
was hungry anymore. Some ate it

nonetheless, but not me, I knew
I had had my fill of the wonderful life,
it was time to go home, go to bed,
a little bit hungry but already ravenous
for the next day, and all it couldn't fulfill.

Man of the Cloth

I have a silk handkerchief in my pocket
into which, in the course of this day,
I will surely blow my nose several times.
The shirt I am wearing, made in Bangladesh,
is one hundred percent cotton, as is
my underwear, product of Vietnam
and these beautiful warm alpaca wool socks
which allow me to cover the ground
with impunity, and my trousers, ordered
by mail from the Territory Ahead
and the Hugo Boss suit I never wear
but am saving for the proper occasion.

No one can tell me I am not a man
of the cloth, or that it isn't worthwhile
to follow me into whatever abyss awaits us.
You will not be wasting your time,
I assure you, if you heed my words
or give yourself up to my congregation,
for mine is the power and the glory
here on earth, as it will be in heaven,
and you who are reading this are my faithful,
you are the beautiful flock for whom these words
are a form of enlightenment, a suspension
of disbelief, a kind of love, and let us say: *Amen.*

Maison de Retraite

Forcalquier, France

Mostly they come here on a one-way pass
Theirs will be no further luncheons on the grass
The entrees puréed, not to chew
Of little interest, the view
From the windows of *la montagne de Lur*
The kind of thing the living don't abjure
Unless, of course, they're diapered in a *couche*
And all that's left's the swatting of a *mouche*
The rising little boat of the spittoon
The only sure emolument of noon
A smile, a wave, a joke, and then a kiss–
O Lord, is there no better way to die than this?

Evening Song

There is very little we can do
for the dead: They are so quiet
in their new homes, they ask
so little of us, really. Each day,
the list of those I know living
in that new community grows—
there are so many of them now
they are starting to seem
like a village of their own
that I could visit at will
and then return from, bringing
their scents and voices back
into my bed like a lullaby. Even now,
the border between us seems to be
shrinking, we're more like a federation
than separate countries, the drinking age
the same in both places. Somehow
it relaxes me now to be thinking of them—
I suspect they are no happier or unhappier
than we are, that their tables are still set
with beautiful cloth napkins and flowers
and that they, too, are choosing the music
from their iPods and stereos, something
to listen to when they light the candles
(jazz in the evenings, classical at lunch)
and that it is all one communal feast

(no break)

we are seated at, the food warm and
delicious, the company good, the cowbells
echoing from the hills and calling our names.

Be Grateful

Each day I say to myself
be grateful be grateful be grateful be grateful
be grateful for your bad back
and sometimes difficult marriage
be grateful for the wind
now blowing over the Gulf
grateful for the ice storm
you are missing back home
be grateful for all the inclemencies
and bad weather, grateful
for the missed opportunities
and the ones you have taken advantage of,
grateful for the trains you missed
and the ones you have taken,
for the beautiful women you sat beside
on the subways and the homely ones, too,
be grateful that it is February, your least
favorite month, and that soon it will be March,
the one, for better or worse, you were
born in, and then for April, when your
wonderful son entered the world,
be grateful for all the countries you
have lived in, and for Borneo, home
to the orangutans you have not yet gotten
to visit, and for the fact that the ingredients
of all the products in the supermarket

(no break)

must be written on their labels, so you can
help those lovely creatures live longer
by avoiding palm oil; be grateful, too,
for palm oil itself, which can embellish
the taste of certain foods, and grateful
that you still have the energy for gratitude
and that, once it wears you out, you will
be able to be grateful for all you were grateful for
and you will be able to sleep, and you
will be able to whisper the names of your gods
into the air, and the air will answer in kind
and be grateful to you, and whisper your name.

Don't Die

It is not very nice of people
to die on you. Not your parents,
not your loved ones, not
your children nor your friends
most certainly not your enemies
before you have a chance to forgive them.
It is not good of your childhood sweetheart
to die, nor the tyrant who fired you
from your first employment,
and certainly not the man behind
the register at the Seven-Eleven
who served you chicken wings
and slices of pizza in spite of your
high cholesterol and simmering obesity.
It is not good of them to die of AIDS
or of COVID, not good of them to die
of Alzheimer's or by their own hands
to save themselves from its ravages. It's
not good of them to die young, or to
die old, not good of them to die in mid-age
in a car accident or in a hospital bed
and certainly not good of them to die
after terrible suffering or just after having
discovered the infidelity of their loved one.
O friends, please don't die, any of you,
and don't let me die as well, I don't think

(no break)

dying is any fun and surely we must
keep on working at loving each other
no matter how close to our necks
the guillotine is hanging. We have to
go on pretending dying doesn't exist
though several of our friends have died
in recent weeks, though the childhood
gods we thought were watching over us
have directed their attention elsewhere;
we have to go on being our happy-go-lucky
selves, the hell with death and dying,
the hell with loss and betrayal, we have to
tell dying to go fuck itself, to look for
its sense of a good time elsewhere,
to leave us for another day, another year,
another century in which we will be better
able to live with it, in which there will be
no one left to kiss whom we can regret
having forgotten, no one to miss us,
no one left singing over our graves.

It's Fantastic

It's fantastic to be young and naked
and fucking on a stone in a river
beneath the late summer sun. It's fantastic,
to feel immortal, that there are no
dark clouds awaiting you, fantastic
to feel your flesh, and that of your
beloved, will always be firm and supple
and eager for pleasure. It's fantastic
to wake every morning, flush with desire
and hormones and appetites
reaching in every direction, fantastic
to live in a world without limits
where abstinence is sinful and the
vast termite mound of possibilities
rises each morning from the earth
like the grapes of Tantalus, hands
reaching for it in every direction.

And it's fantastic to be one of those chosen
for the confluence of sperm and egg,
fantastic to have defied all the odds
and been uttered out into the ambiguous universe.
It's fantastic to be able to move your fingers
over the keys and make words, it's fantastic
that some of those words will have meaning,
fantastic that the very same words may

(no break)

make someone laugh or weep in far-off
Burkina Faso. And it's fantastic, too,
that I am no closer to perfection now
than I have ever been, no closer to sainthood,
fantastic that hypocrisy is alive and well
within me, and that I will never be the angel
others want me to be, that this is as far
as I have come, and as far as I can go.

And it's horrible that we are all dying
and will do so in time, with or without
our loved ones there beside us. It's horrible
that Calvino was right, and the ultimate meaning
to which all stories (and poems) aspire
has two faces: the continuity of life, and the
inevitability of death. It's perfectly horrible,
yes, that, in a few years, I will no longer be here
looking out the window at my Hungarian backyard,
I will no longer be able to watch the nuthatches
wedge their seeds into the crevices of the trees,
no longer spend summer mornings swimming
in Lake Balaton and no longer be able to look back
upon my many follies, for my follies will be over.

But it's also fantastic to be old
and no longer interested in fucking,
fantastic to be sitting on this raft
in the middle of Lake Balaton on a brilliant

(no break)

June morning and to feel this fly on my arm,
yes, it's fantastic to navigate between the shit
of the gulls and the shit of the terns to find
a clean place to sit on this raft, fantastic
to be free of lust and see the world again
as you saw it emerging from the womb,
and not have to cry out for your mother
or anyone else's, and to have to cling to her dress,
sobbing, when she drops you off at school.

Yes, it's fantastic to be free of all that,
free to love only the air and the nothingness ahead,
free simply to take in the stupefying beauty
of this world, the many brilliant organisms
and their incredible little mating dances
and to know that you have done
what you have done and that you will get done
what remains to be done, and that now
it is the turn of others to have their hearts broken
and frolic in the sun and hallucinate upon a bush
and picnic naked on Wellesley Island
watching the Asian fisherman troll for Northern Pike.

And it's fantastic not to be dead yet, though
at times you've wished you were, it's fantastic
to know that once upon a time it was you,
fucking on that stone, and that now it's the turn
of others, it's all fantastic, friends, once

(no break)

the pain subsides, the entire show from start
to finish, it's fantastic to be, to have been,
to become, and still hope there may yet be
some strange miracle by which we will all
somehow live in peace, and that, someday,
in some form, we may yet come again.

ACKNOWLEDGEMENTS

Several of the poems in this book were previously published in the following journals and magazines, which the author gratefully acknowledges:

TRANS-LIT 2
> "Avalanche"
> "Happiness"

PITTSBURGH POST-GAZETTE
> "Hypocrisy"

POETRY EAST
> "Freedom"
> "Life List"
> "How Not to Die"
> "Sitting Around"

THE MISSING SLATE
> "Book-Buying"

POETRY PORCH
> "Stone-Hearted"
> "For a Friends, Whose Son Has
> Been Admitted to an Institution"

My thanks to my dearest friend and soul-brother, Jack Estes, who not only always offers me his good counsel and wise advice, but so often saves me from myself. And to my deeply talented friend Jonathan Hirschfeld, for letting me use the reproduction of his beautiful work on the cover. Lastly, my profound gratitude to my wonderful publisher Erin Chandler for the integrity of her vision and the kindness of her heart, and to the designer of this book, Corbyn Keys, for putting up with my fickle, Piscean nature.